Leisure Arts 2

Working with Watercolour

Leslie Worth

SEARCH PRESS

Wellwood North Farm Road Tunbridge Wells

Introduction

Watercolours are, as their name suggests, pigments ground in water and bound with gum or a similar substance. Painting in watercolours was one of the earliest arts discovered by man, and has continued in various forms over the centuries until the present day, when there is a reawakened interest in its use.

Watercolour painting is essentially a small-scale art form, but it is capable of rich and personal expression. It is important to recognize the limitations and exploit these to advantage. Watercolours call for clear thinking and spontaneity of action, for exploration of the balance between broad masses of colour and linear patterns, and the contrasting of limpid washes of colour and sharp, active brushstrokes.

Water is both one of the ingredients of the colours and the vehicle in which the colours are applied — and to use the medium successfully, you must learn to control the delicate balance between the water content and the amount of pigment picked up on the brush.

Many people think this means a full brush and great floods of water on the paper and 'the wetter the better'! This is not so. When learning to handle the medium, it is a good idea to err on the lean side and to use only just sufficient water. With experience the water content can be increased.

Anyone who paints with watercolours soon realizes that the medium has a life of its own, which can be exploited but rarely completely subdued. The washes are governed by the force of gravity and the colour will tend to run down the paper, especially if you are working on a tilted board; wet areas will 'bleed' into one another; and furthermore, the colour will dry out rapidly or not at all, depending on the humidity of the atmosphere. Every watercolourist must learn to anticipate the colour values in advance and make allowance for the loss of tone when the water evaporates.

Once you have learned to use it, you will discover that watercolour has a beauty and inner poetry unrivalled by other forms of graphic expression. It is perfectly conceived for conveying the moods and vagaries of light and colour in the landscape, and its immediacy and delicate sensibilities make it ideal for capturing those fleeting moments of experience denied to the more ponderous and premeditated media.

For the sake of clarity and to reduce practical difficulties the succeeding stages in each example were painted separately. Eagle-eyed students will detect minor differences between them — I hope they will overlook them to concentrate on the principles which are demonstrated.

Brushes

The best and traditional brushes used in watercolour are sable. They are expensive, but are soft and springy and with care, keep their shape.

Oxhair brushes are much cheaper than sable. They are coarser and more springy — useful in less delicate passages.

Cheaper still are squirrel hair brushes, often sold under the name of 'wash brushes'. These are soft but rather floppy, and I find them quite inadequate.

Choosing a brush

Buy as good a brush as you can afford — manufacturers grade them according to quality and the prices will reflect this.

When choosing a brush, ask the dealer to provide a jar of water, dip the brush into it, withdraw it and give it *one* vigorous flick. If it is a good brush the tips of the bristles will form a perfect point at once. If this does not happen, reject the brush and try another.

Care of brushes

Given care a good brush will last for years; and a few sensible precautions will ensure that it does.
1. Treat the brush respectfully; avoid hard scrubbing with it.
2. When you have finished using it, rinse it thoroughly in clean water. Make sure there are no particles of pigment clogging the ferrule.
3. If the brush becomes very discoloured, clean it with good-quality soap, then rinse it thoroughly in water.
4. After washing, shape the brush with your fingertips, or between your lips if it is quite clean, and set it aside to dry.
5. Never put wet brushes away in a closed container.
6. Protect the tips by carrying brushes fastened to a metal or wooden strip in a brush-carrier. The protective strip must of course be longer than the brush in order to protect the tip.

If you observe these rules your expenditure will be amply justified.

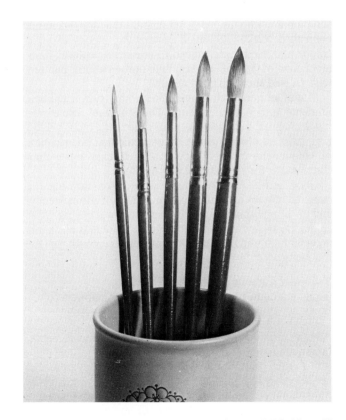

A few good brushes, say one each of sizes 4,7,8,10 or 12 will give you a good working basis.

Colours

Watercolours are basically pigments ground in water and bound with gum. They also contain glycerine to keep them moist, and a 'wetting' agent.

They are sold in pans, either half or whole pans, tubes, or cakes. Pans are convenient to use and the colour can be controlled easily. They are my own choice. Tube colours are ground to a more liquid consistency. They are useful for painters who use a lot of colour, but are less easily controlled. Cakes are small rectangular blocks of solid colour and need to be rubbed to release the colour. They are favoured by the purists, but inexperienced painters tend to find them difficult to use.

Manufacturers sell watercolours in two qualities, Students' and Artists' colours. The Students' colours are much cheaper, but again the price reflects the quality and I urge painters always to use Artists' colours. The richness of colour, the covering power and delicacy more than compensate for the extra outlay of money.

Good artists' material shops issue cards showing the range of colours and their relative degrees of transparency, and it is advisable to study these before buying your colours. A basic range of eight or nine colours is all that is necessary. A reliable basic palette might consist of the following.

Yellows Aureolin, Raw sienna
Reds Light red, Vermilion, Alizarin crimson
Blues Prussian blue, Monestial blue, Indigo

Auxiliary colours might include chrome orange, sepia, brown madder, cobalt violet.

Gouache colours, like poster colours, are opaque and are intended for body-colour painting, as opposed to the transparent pure watercolour. For some passages where a little opacity is required, certain distant sky effects for example, I recommend using Chinese white, which may be purchased in pans, tubes or small jars.

A basic palette

I have chosen the eight colours (shown opposite) to give as wide a potential as possible. However, a basic palette is finally a personal choice, and you will eventually want to make your own modifications.

I painted out the eight colours in strips, starting at near full strength and diluting to a pale tint. Then at right angles to this I painted four bands of colour. You will see from this how other colours are created by optical mixing (laying one colour over another), and also to what extent basic colours may be modified by mixing and diluting.

You may find it useful to make a similar grid, and see what other facts of colour behaviour may be observed.

Key

1. Aureolin: a sharp, clear yellow, rather gentle in action.
2. Raw sienna: an essential earth yellow, warmer and less muddy than its close relative yellow ochre.
3. Light red: a delicate earth red which may safely be used in the quietest passages and yet, used pure, is capable of vibrant energy.
4. Vermilion: an apparently brilliant colour which is in fact very quiet in behaviour.
5. Alizarin crimson: a strong purple red which is useful in certain circumstances but must be used with care, as it bleeds into other colours.
6. Prussian blue: a beautiful cool, clear blue, quiet in spite of apparent pungency. It produces clear greens and subtle greys in mixing.
7. Monestial blue: a modern colour, strong and vibrant, somewhere between Prussian blue and ultramarine blue.
8. Indigo: an old favourite, of great range and power, graduating from near black to soft grey.

Cross bands are made from the following colours.

a. Prussian blue. c. Vermilion.
b. Alizarin crimson. d. Aureolin.

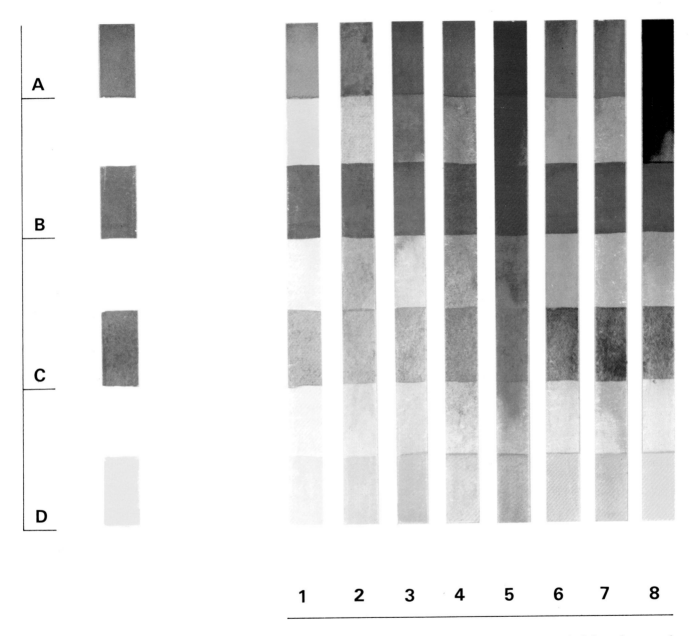

| | 1 | 2 | 3 | 4 | 5 | 6 | 7 | 8 |

N.B. You will note that the palette contains no green. I find greens in watercolour generally unsatisfactory and lacking in density. The chart illustrates how some greens may be made by mixes of various blues and yellows.

A basic palette. Make gradations of eight colours and experiment with mixing and overlaying.

Paper

The paper you use will influence your painting more than any other item of material. Its characteristic behaviour, determined by its manufacture, will dictate the range of expression and thus the ultimate character of the work. So it is essential to understand the nature of each paper and to choose carefully. You will need to experiment to find which surface suits your own purposes best.

Paper is made up of a close web of interlacing fibres which trap the tiny particles of colour and according to the density and irregularity of the fibre mat give sparkle and vitality to a painting. Generally speaking an irregular surface will yield a livelier effect than a smooth, regular one.

You may of course paint on any paper which suits your purposes, but there are papers made specifically for watercolour painting.

These are sized during manufacture so that colour may be spread evenly over the surface and succeeding layers built up without too much loss of luminosity. In practice this sizing varies even among papers of the same type — so again you will need to experiment to discover the various behaviour patterns.

Watercolour papers are divided into two main categories, handmade and mould-made (machine-made). Handmade paper is characterized by an individual and relatively irregular surface. Naturally, it is expensive. Mould-made paper is regular in surface and cheaper, but perfectly adequate for working on.

Both papers are made in three surfaces, *Hot-pressed, Not* (Cold-pressed), and *Rough:* basically, smooth, medium and rough surfaces respectively. They are classified by weight, in either grams per square metre or pounds per ream (500 sheets), for example 150 gsm/72 lb., 635 gsm/300 lb.

To avoid cockling, stretch the paper before using it. Immerse the paper completely in cold water for a few minutes, then remove it and lay it flat on a stout board. Take up the surplus water with clean blotting paper (do not rub!) then stick the paper down on the board with gumstrip (adhesive-backed brown paper strip) around the edges, sticking approximately one third of the gumstrip on the paper and the remainder on the board. As the paper dries out it will contract and pull tight like a drumskin. Be sure to lay the board perfectly flat while the paper is drying: if it is tilted the water will drain to one side, so that the paper dries unevenly and pulls off the board.

The wash

The wash is the basis of the traditional method of transparent watercolour techique. Applied with the correct balance of water/pigment content, flat, graduated, broken or overlapped, it is the foundation on which nearly every watercolour painting is laid.

It requires sensitive brush control and the ability to judge the right amount of water and also what the colour values are going to be when the painting has dried.

By varying the density of the stain you can make a few pigments express a wide range of colours.

The following notes, supported by the demonstration and key may help to clarify some of these issues.

Demonstration

Size; 200 x 200 mm/8 x 8 in. Paper; TH Saunders NOT 135 gsm/90 lb. Brushes; 7,10 sable. Time taken; 2 hours. Colours used; raw sienna, light red, Prussian blue, indigo.

Fundamentally the scheme is a complementary one: warm/cool — yellow/blue. The mixtures provide the supporting, modifying or tempering values.

The basis is a graduated wash of blue and yellow over which are laid minor areas of blue + yellow, yellow + red, or variations of all three, blue + yellow + red. Sometimes the areas bleed into one another, for soft passages, as in the distant base of the cloud or the shadow area in the right foreground.

Key

a. White (virgin) paper.
b. Raw sienna painted into wet area of cloud and descending to cover whole of ground.
c. Prussian blue, unadulterated, as in top sky, overlaid on warm ground, as in foreground, or physically mixed with the raw sienna on the palette, as in the darker cloud passages.
d. Prussian blue in double strength overlaying wash or mixed.
e. Light red, modified by a certain amount of blue.
The sea area is a mixture of indigo with a little light red. Notice how secondary colour values can be created by overlapping complementaries or direct mixing. Incidentally a yellow overlaid on a blue, for instance, will produce a different result from a blue overlaid on a yellow. This principle can be exploited to great effect and variety.

Never forget that while it is important to work within a planned range of colour, it is impossible to foresee everything in a painting — so use the accidental passages and unexpected harmonies of colour, and be grateful for them!

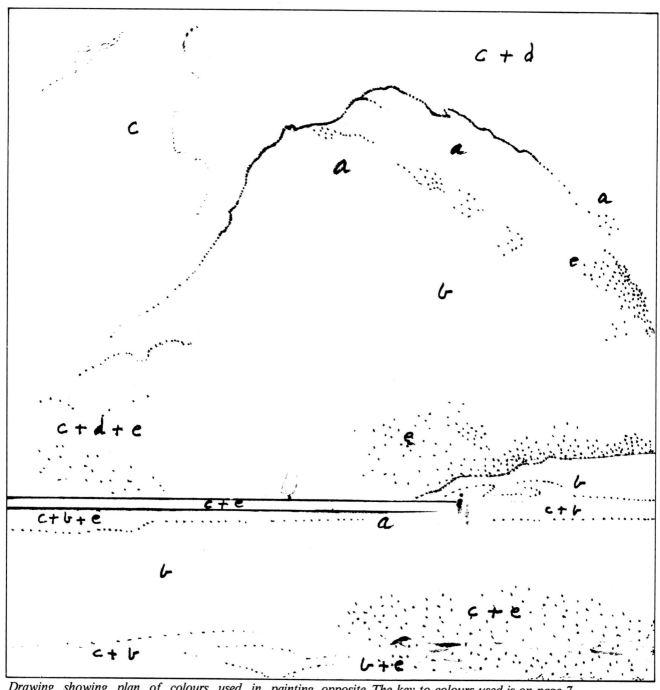

Drawing showing plan of colours used in painting opposite. The key to colours used is on page 7.

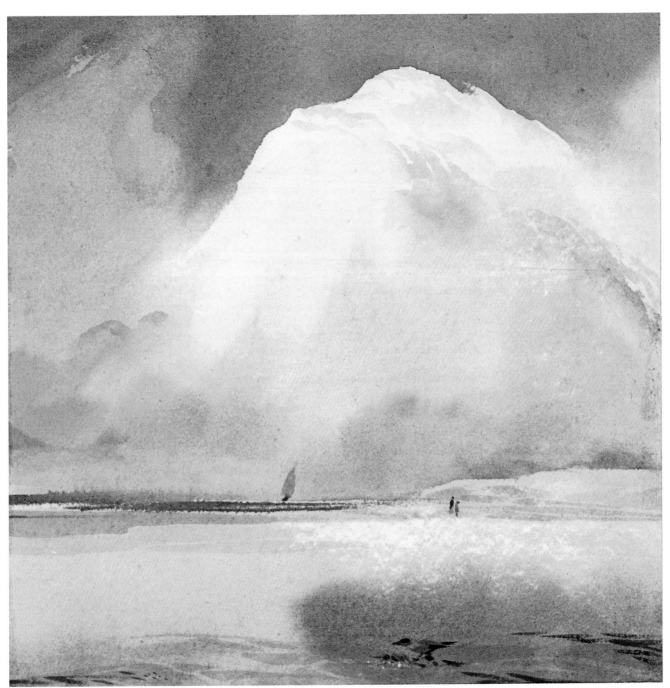

The beach: a demonstration of flat and graduated washes.

Sea and sky

Because of the obvious interdependence of these two elements, they have been combined in one demonstration.

The Sky

The sky, being the source of all light, is the dominant feature and exercises a governing role in the painting. By its nature it establishes the mood of the painting, be it peaceful, tempestuous, buoyant or oppressive.

It can be complicated, so it is essential that you should look at it carefully to discover the basic organization. You will find yourself in appalling difficulties if you sit down and try to copy what you see without analyzing the subject and interpreting it in terms of what the medium can cope with.

Obviously, basic technical considerations will determine how you work. For example, you can only work: 1. from light to dark; 2. from top to bottom of the paper (because watercolour washes run downwards); 3. from relatively large and simple masses to the more complicated.

Examine the sky and note the position of the sun, the direction of the wind, movement of cloud masses, flow of colour, and so on. Be selective and simplify.

The Sea

The same basic principles should be followed in painting the sea. From a physical point of view the sea will start where the sky finishes on the paper; this invariably gives a less hard line than one imagines. The horizon may be five miles distant or more, depending on visibility and the position of the observer.

The sea is basically a reflecting surface and depending on its own activity, rough or calm, will incorporate colours found in the sky. The changes in its surface, shadows of waves, and so on, should not be overstressed. Light areas, such as breaking waves, may be left as virgin paper, or, if they are small and isolated, picked out with a sharp knife.

The water surface is not uniformly translucent. Near the beach where the depth is shallow, the underlying colour of the shore will influence it, and it will often be a rich green. Farther out the colour is heavier and will change, sometimes subtly, from left to right.

Demonstration

Size; 180 x 180 mm/7 x 7 in. Paper; TH Saunders NOT; 135 gsm/90 lb. Brushes; 7,10 sable. Time taken; about 2 hours.

Stage 1

Establish the key or mood of the painting at this stage. The sky is the most important factor as it is the source of light. Lay on a soft wash, keeping the colours light and airy and aiming for simple spaciousness. The colours used here are: raw sienna, indigo, Prussian blue and sepia.

Stage 2

Colour in the sea and foreground beach to establish them more firmly. Strengthen the sky by adding colour, but do this carefully or the sky may become too heavy. Dampen the horizon on the right to allow the stronger tone on the left to bleed out.

Stage 3

To complete the sky, damp the surface of the paper with a soft sponge and paint in the clear blue area, diminishing it in strength downwards.

Give shape to the top of the breaking wave by using a sharp blade to lift out the painted area. Do this very carefully or you may damage the surface of the paper.

Stage 4

Put in further details of the headland on the right, and the dark line of the wave in the middle distance. Put in the darker areas inside the breaking wave and darker accents in the beach foreground. Take great care to avoid overstating the tonal values of these details when you add them in.

Stage 5

The final painting. Little is added to the previous stage, except details. Put in the figures and the gull at this stage, and not before. Consider their scale and tonality and put them in on dry paper to give them sharp edges. Add a few details on the beach and lift out some light streaks in the foreground with a sharp knife.

Stage 1

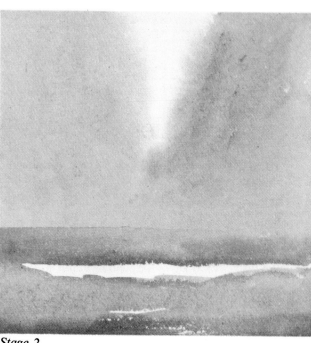

Stage 2

Stage 3

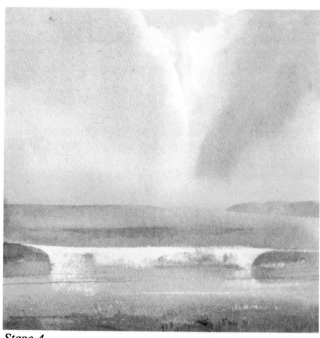

Stage 4

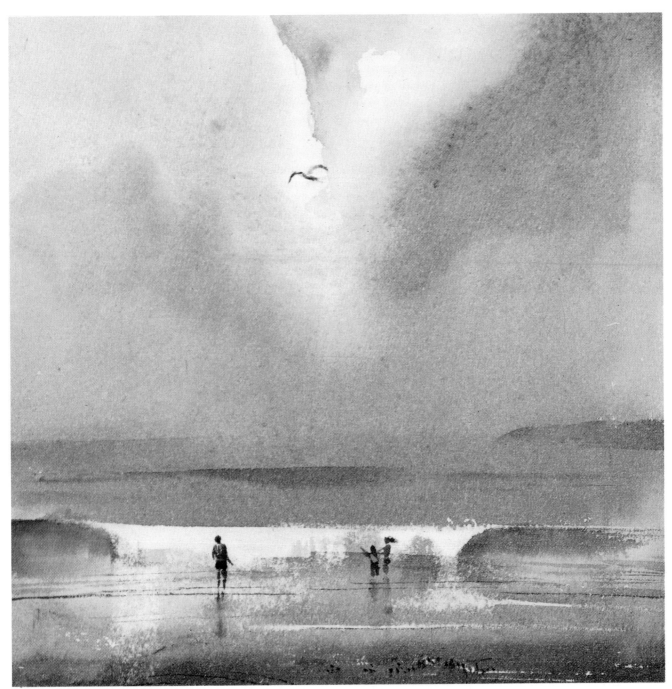

Stage 5 — the finished painting

Landscape

This watercolour was painted on the edge of the Surrey Downs, looking north-west. It was a light, fresh morning early in March, with a cold westerly wind blowing (from the left to the right of the picture), a fair amount of cumulus cloud building up and some hint of rain to come.

Basis of the painting

I was attracted by the quality of silvery light over the landscape, sharp but subtle in colour, and the sparkle of accents in the conifers and houses in the middle distance.

The painting operates on a simple structure of contrasting, complementary colours. The field and foreground are basically warm yellows containing, raw sienna, chrome orange, monestial blue, violet. The cool sky and distance are basically blues, and contain indigo, monestial blue, light red and violet.

Note that in the colour mixes, each colour division contains elements of the opposite (complementary) colour value as a qualifying ingredient. For example, in the field and foreground (warm) sienna and orange, the dominant colours, are modified by blue and voilet.

The middle distance

The trees and houses in the middle distance provide the main subject interest. Here the colours are a mixture of warm and cool elements and, colourwise, lie between the main divisions of yellow/blue, ground/sky. The colour mixes (from the colours listed above) are subtle and close in value, relieved only by the dark accents of the conifers and the light forms of the horses in the far field.

The sky passages

Even on a clear day, the sky is rarely a flat blue. The presence of vapour, the inclination of the sun, and so on, introduce changes from top to bottom, left to right,

according to time of day, weather conditions, and the position of the observer. It is very important to be aware of the mood of the sky, as this will determine the character of the landscape.

Notice that the strongest colour in the sky is overhead. The colour becomes progressively fainter as the atmosphere thickens towards the horizon. Dust, smoke, moisture, and so forth, will also bring about changes in the light and a general opacity.

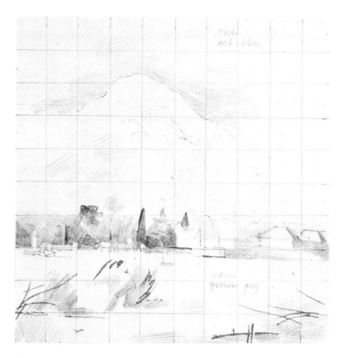

A squared-up working drawing. Note the tonal weights given to features and the trees in particular.

Demonstration

Size; 170 x 170 mm /6¾ x 6¾ in. Paper; Arches 135 gsm/90 lb. Brushes; 00,7,10 sable. Time taken; 3 hours.

Stage 1

The first step is to establish the overall mood of the painting, through the chosen range of colour and lighting. This requires careful rehearsing of the presentation and selection within the subject in your mind before you commit brush to paper. Make a sketch or do a working drawing to clarify your ideas. It may be too late to change anything drastically afterwards, although some modification may be possible. Notice that at this stage the sky is almost fully realized and only minor details are added later. Although the main divisions of sky, distance and foreground are stated, there are no hard edges. To achieve this effect, damp the paper all over, except for the lightest part of the cloud. Do not get the paper too wet, or it will be difficult to control. Mix enough colour on your palette to cover the chosen area. Work from the top of the paper down. Allow this stage to dry completely before proceeding to the next.

Stage 2

The aim here is to qualify the sky a little more and to indicate the far distance. Damp the sky area above the cloud with a sponge or clean brush. Then introduce a little stronger blue into the sky and stronger, darker colours into the cloud mass, to give it more fullness.

Now paint in the high ground in the distance. Damp the paper to the left and right of the cloud mass and then take the colour across the paper. This will give a slightly sharper line in the centre.

Stage 3

Brush in the darker masses of trees in the middle and far distance, isolating the forms of the two houses on the right. Add the foliage mass in the left foreground. Keep the tones subtle and damp the paper in advance where necessary.

Stage 4

Add the sharper accents of the conifers and houses in the middle distance. Damp the paper beneath the conifers before painting them in, so that the trees rise gently from the ground. Isolate the lighter accents of distant walls and fences by painting darker tones around them. Add shadows gently where necessary.

Stage 5

The completion of the painting and the moment of truth. Most of the work has been done and little needs to be added. But what remains is critical. Look over the whole of the painting and consider it. Do not regard this stage merely as an opportunity to add extra detail, but endeavour to bind together the whole, suppressing anything which is disruptive and strengthening weak passages. The small details we love to include will then serve to emphasize the breadth of the whole painting.

Add the line of rushes in the near foreground and, using the tip of a sharp blade, pick out the forms of the horses in the field, the light accents of distant lamp-posts and the bare twigs in the foreground.

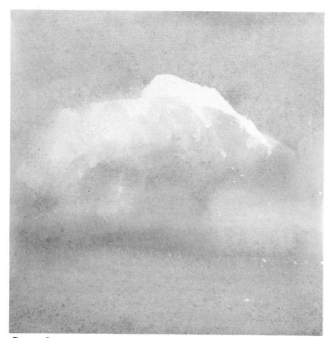

Stage 1

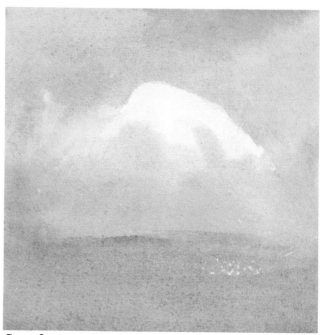

Stage 2

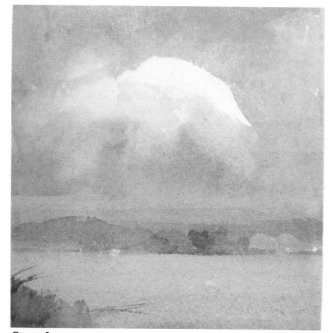

Stage 3

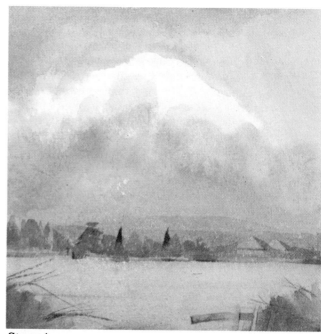

Stage 4

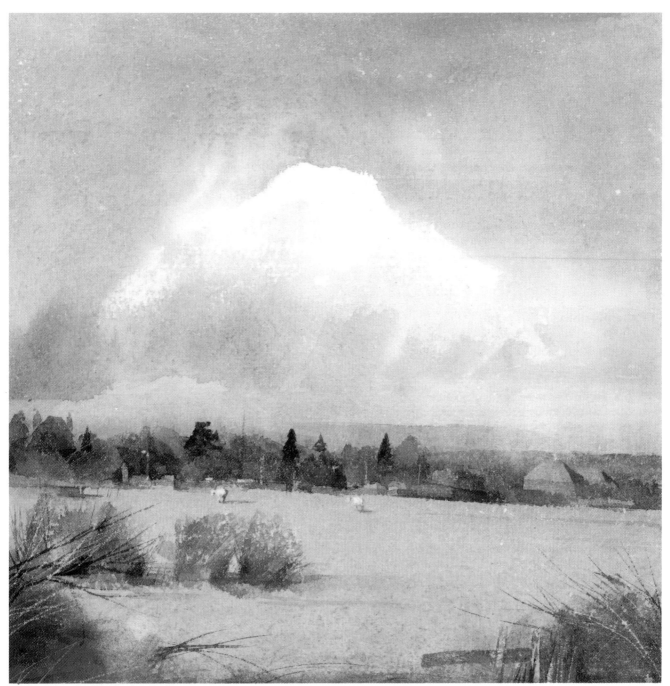

Stage 5 — the finished painting

Trees and foliage

The painting of trees and foliage presents the painter with some of the most difficult problems in watercolour. The subjects are almost always complicated and the inexperienced painter may well be overwhelmed by the profusion of detail and at a loss to know how to represent it. I have vivid memories of trying to cope with these problems, and although my solutions have not always been successful, here are some observations which may be useful.

Choice of subject

At first, choose subjects which are lit in a lowish cross light — early evening may be the best time. This will simplify the leaf masses for you, and make for easier comprehension.

Select a subject at some distance, so that the grouping is simplified. (Corot often adopted this device; he also used to view his subjects in a fading light when the forms were simplified.)

Tactics

It may be helpful to make a small drawing beforehand, to explore the problem and attempt to organize the complexities in your own mind before putting brush to paper.

For your painting, choose a paper of moderate weight and surface, not too absorbent. Stretch it in advance and do not apply the colour washes too wet or control will be difficult.

Observe that in a subject well defined in masses of light and dark, the tones within the light areas must remain light, and in the darker areas relatively darker. Do not allow them to intrude on each other.

Notice too the subtle but considerable modification of colour within any given area.

Remember that your brush is a *drawing* instrument and the individual marks you make must shape the volumes you are describing.

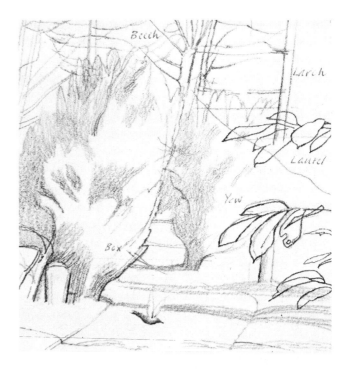

A compositional drawing done to work out the balance between the strong main features and the soft areas of foliage.

Demonstration

Size; 170 x 170 mm/6¾ x 6¾ in. Paper; Arches 135 gsm/90 lb. Brushes; 00,7,10 sable. Time taken; 4 hours.

Notes on the demonstration painting

The watercolour here was painted at the edge of a park over two mornings in late March. They were days of bright sunshine, relatively warm, with a light breeze blowing.

I made a drawing in order to sort out some of the elements of the subject. It consisted essentially of a large, rather ragged box tree and a darker, more formal yew. These solid forms contrasted with the more linear shapes of the larches and beeches beyond, and certain accents of interest in the laurel leaves and other details.

Stage 1

The complexity of the subject calls for some preliminary guidelines. Indicate the placing of the main proportions of the trees and path with a light pencil drawing. Brush a wash over the drawing to indicate the principal colours of sky and trees. Keep edges soft by painting wet into wet (but not *too* wet). Leave light foliage areas as blank paper. This stage should indicate the overall mood of the painting.

Stage 2

When the first stage is quite dry, pick out the main masses of the subject. Using rather muted values and following the direction of the light, give the trees volume. The colour in the shadow areas inclines to violet, and the warm golden light areas complement this. Indicate cast shadows across the ground. These help to give depth to the study, as does the dark accent of the laurel leaf in the foreground. Colours used: cadmium yellow, raw sienna, light red, Prussian blue, indigo, cobalt violet.

Stage 3

Indicate the stems of the trees in the distance. Add more detail to the large box tree in the foreground, concentrating on the description of the shadows of the leaf masses. Strengthen the colour throughout where necessary.

Stage 4

Strengthen the indications of the background trees. Introduce greater depth of colour into the shadow areas. Develop the finer details of the box tree and the yew and build up the shadow surrounding the yew to pick out the light stem. Paint in the laurel leaves in the foreground. Use a sharp knife to lift off areas of broken light on the path.

Stage 5

The finished painting. Using a fine brush, add detail to the foliage. Pick out the pale stems of the foliage with a sharp knife. Strengthen the colour washes overall. The blackbird flying across the path was introduced to give some movement in the painting.

I have reservations about the success of this painting. The background is not sufficiently mysterious, and the laurel leaves lack intensity.

Stage 1

Stage 2

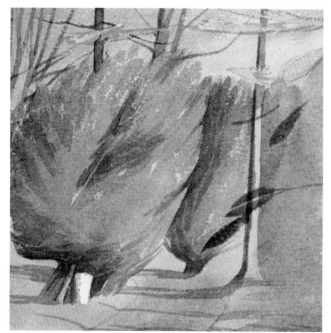

Stage 3

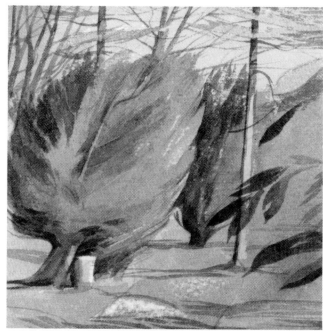

Stage 4

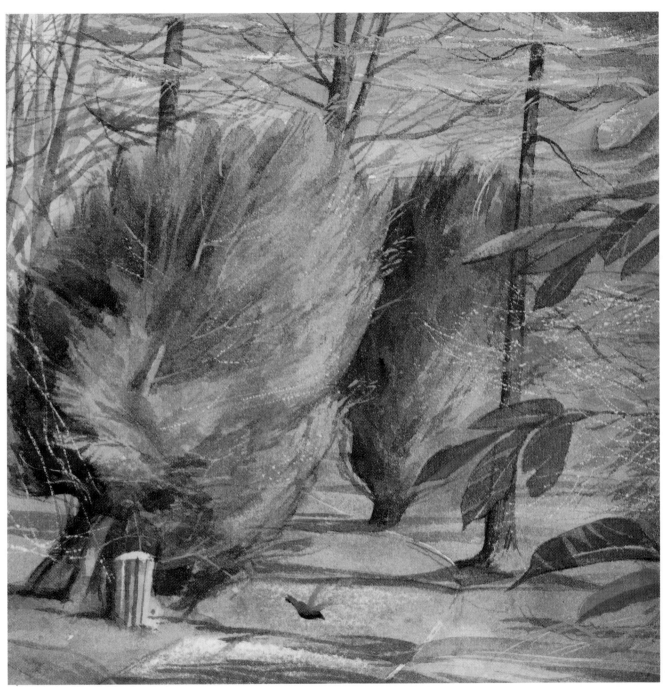

Stage 5 — the finished painting

Buildings

Because of their infinite variety of shape, colour and texture, buildings of all sorts provide a rich fund of painting experience. I would advise that you begin with something simple, but which nevertheless has an attraction for you.

You will be concerned with representing the structure of the subject, so your powers of draughtsmanship will be put to the test, and the basic principles of perspective will be involved.

In painting a building there are two aspects to be considered. First is that of representing the building in its true proportions and scale in relation to its surroundings; this may be thought of as the *drawing* aspect. Secondly, there is the relationship of colour, texture, light and the sheer material presence of subject — the *painting* of it. In practice, of course, these two aspects are indivisible.

A working drawing. I have noted colour values on the drawing as the quality of winter light changes so rapidly. In the painting (overleaf) I added a dark tree on the left and made other minor adjustments to give a better balance to the work. This drawing was done in two hours.

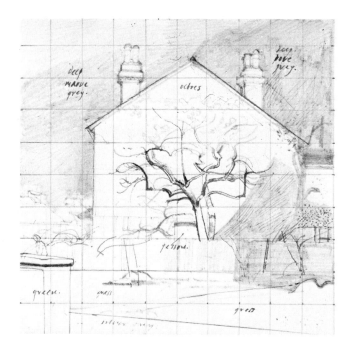

Demonstration

Size; 170 x 170 mm/6¾ x 6¾ in. Paper; Arches 135 gsm/90 lb. Brushes; 00,7,10 sable. Time taken; 3 hours.

Notes on the demonstration painting

For the purpose of demonstration I selected a fairly simple subject, the end gable of a cottage which stands in a terrace.

The time was between 11.00 a.m. and 12.30 p.m. on a late February day. The weather was mild but threatening rain, the sun, strong and lying to the right; heavy grey clouds forming ahead made a dramatic foil to the ochre stuccoed surface of the cottage. The solid sombre elevation contrasted with the delicate linear tracery of the apple tree, and an interesting variation was introduced by the angular cast shadows of a building to the right of the picture.

I made a drawing on the spot of the subject and carried out the painting from the information conveyed in the drawing.

Essentially the colour structure is a simple complementary scheme of yellow/violet with a minor red/green counterpart in the fencing and foreground grass. The colours are muted, the yellow being ochre and the violet a soft dove-grey.

Stage 1

Make a light pencil drawing of the structure and brush over it washes based on the lightest dominant colour value. Treat the washes freely and allow the maximum unity of lighting overall and between sky and ground. There should be a suggestion of the final balance of warm to cool areas within the scheme of complementary colours at this stage. Try to establish the general mood and key of the painting at the outset. Colours used: raw sienna, chrome orange, indigo and monestial blue.

Stage 2

Complete the sky passages at this stage in order to preserve freshness of execution. Put in the dark accent of the yew tree on the left; this is valuable to give a key to some of the middle passages of colour. Paint in the principal colour values of the stuccoed gable, putting in the lighter, flaking area in the centre with a dry brush. Brush in the darker, cooler areas towards the bottom left while the paper is still damp. Be careful not to get the colours too heavy or jumpy at this stage.

Stage 3

Paint in the shapes of the cast shadows on the right and strengthen the colours in the fence, linking together the right and left sides of the painting. It is important at this point to bind together the large elements of the design, and so avoid fragmentation of the idea.

Stage 4

Introduce details such as the roof, the fencing and the apple tree. These accents of interest set the key for the degree of realism in the painting which will be governed largely by personal choice and ability.

Stage 5

The completion of the painting. Add the architectural details, chimneys, and so on, taking care to keep them in scale with the rest of the painting and to avoid fussiness. Finally, look over the work as a whole, pulling together the colour washes and strengthening or subduing where necessary.

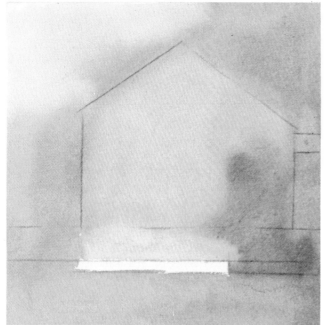

Stage 1

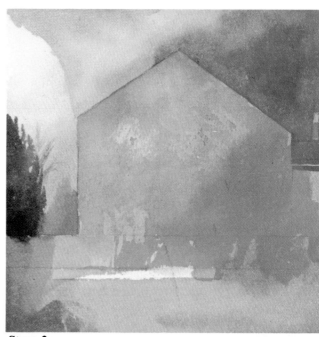

Stage 2

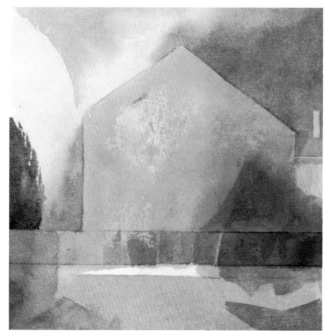

Stage 3

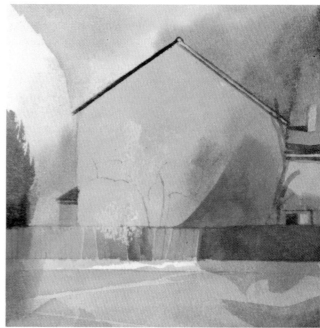

Stage 4

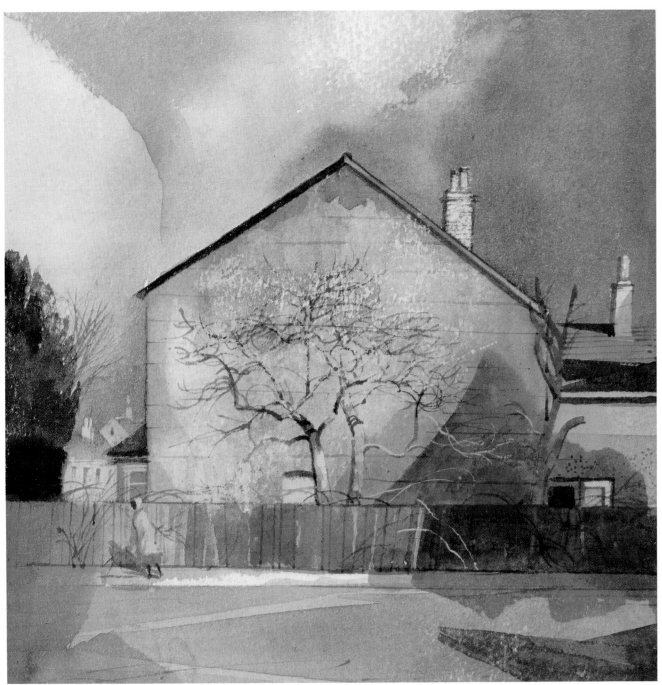

Stage 5 — the finished painting

Water

The painting of water in various forms is one of the most attractive subjects for the watercolourist. Its translucency, limpidity and changing mood allow the painter to exploit watercolour to the maximum. Of course, hand in hand with the beguiling charm go the difficulties, so to start with choose a relatively uncomplicated subject.

The subject

The time was mid to late afternoon early in March, a day of strong wind, bringing a changing pattern of brilliant sun and short, heavy rain showers. The painting was done entirely on the spot, the location is a large pond surrounded on three sides by dark woods of silver birch, oak and ash. Soft, smudgy, warm bands of colour lie across the pond where the reeds and bulrushes grow. The muted light and dark clouds and subdued blue of the sky are reflected in the pond and the surface is disturbed now and again when the wind, darting through a gap in the birches, ruffles the surface. The dark mass of the distant woods and the dazzling light reflection in the foreground make an extreme contrast.

I found that I could paint the subject using only three colours: indigo, light red and chrome orange. I have some reservations about the orange. I like it, but it is very strong and can be treacherous. I used two sable brushes, a no. 10 and a no. 7. Both were springy with good points, so it was possible to paint very fine detail, such as the stems of the bulrushes, even with the larger brush.

Notes on the demonstration painting

As a demonstration I chose to paint part of a pond, and this posed quite sufficient problems, with its varying depth of colour and translucency, its surface smooth yet broken by reeds and ripples, ruffled by the wind and disturbed by a coot. A further complication was the low wintry sun directly overhead, which made a brilliant reflection in the left foreground. Technically, this subject raised the problems of painting isolated light areas within dark ones, and of painting wet into wet while introducing dry strokes, graduated washes and sharp detail. In fact it presented most of the technical difficulties encountered in watercolour painting.

Demonstration

Size; 170 x 170 mm/6¾ x 6¾ in. Paper; TH Saunders 135 gsm/90 lb. Brushes; 7,10 sable. Time taken; 2½ hours.

Stage 1

With this subject the most important thing is to establish *at once* the mood, character of lighting and essential unity. Basically it is a cool, dark subject, shot through with warmer passages (reeds) and with a brilliant contrasting burst of light in the reflection of the sun.

First damp the paper slightly all over, except for the small light area in the sky, top left, and the light reflection below. Starting at the top, brush in a cool wash, making subtle shifts of colour (for the reeds, reflections and so on) as you move down the paper.

Stage 2

At this stage some form must be introduced into the painting and the geography of the subject defined a little more. Introduce lighter reflections into the water in the foreground by gently pushing a folded piece of clean rag on to the painting while the wash is still damp. You had better practice this on a spare piece of paper beforehand, as it is a slightly tricky operation.

When the paper is dry, the wood in shadow at the far end of the pond can be given shape. Take a darker, warmer wash of colour (indigo + light red) down the area, shaping the contours of the trees and carefully steering round the pale stems of the silver birches on the right. Use the same dark wash to indicate the slim dark bands of water in the distance.

Stage 3

I found it necessary to strengthen the tones in the water at this stage, and you may well find that you need to do this too. If you do, make sure that the paper is dry beforehand, or ugly bleached areas will appear. Then damp the paper with a brush and clean water and float on the stronger colour, swiftly, with as little disturbance of the surface as possible. This may sound paradoxical, but as a general rule it is much safer to allow one wash to dry, then damp the surface and work into it again. If you don't believe me, try it and see!

Paint in the reeds and bulrushes, allowing the stems to vanish into a damp area below, so that they are kept well back in the picture.

Stage 4

Now you are almost ready to paint the rippled surface of the water. But first examine the water surface carefully to discover what is happening. You will notice that a pattern emerges. There are deeper, bigger movements of the surface, on top of which are minor, more agitated ripples, and these movements have a rhythmic interplay. Always base your work on sound observation.

Then pick out the light streaks in the water. Use a sharp knife sparingly to do this.

Stage 5

There is really no break between this stage, the completion of the painting, and the preceding stage. The overall purpose here is to bind together the elements of the painting.

Strengthen the dark indigo reflection in the right foreground of the pond. To depict the light breaking over the distant trees, take a sharp blade across the area, lifting out the wash, and allowing a fine line to skim the edge of the trees. Also use the knife to pick out light accents on the heads of the bulrushes and some of the sharper ripples in the foreground reflections.

Stage 1

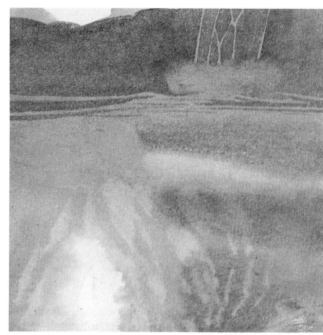

Stage 2

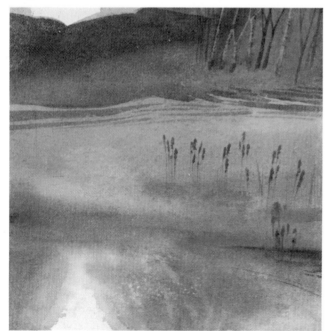

Stage 3

Stage 4

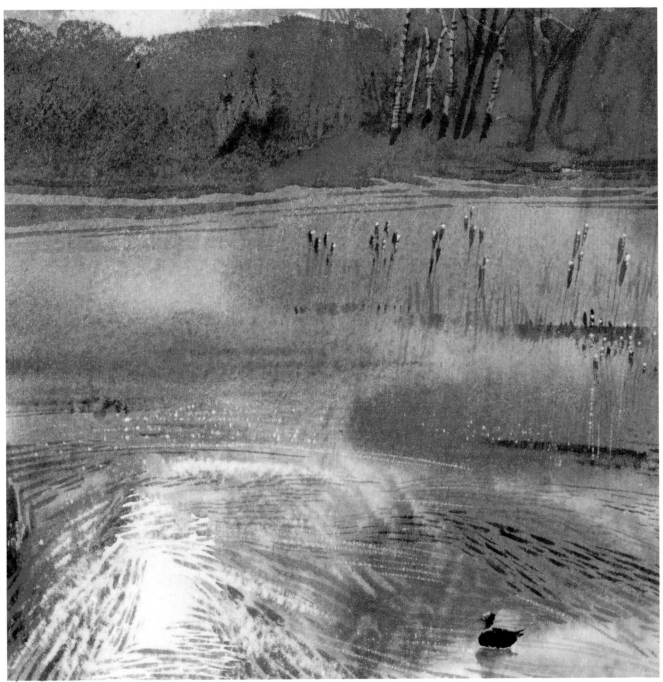

Stage 5 — the finished painting

Suggestions for further work

Watercolour, like any of the arts, calls for dedication, love and patient practice. You will improve and develop your painting in direct proportion to the time and thought you devote to it. However, the second of these elements is more important than the first. Progress depends less on hours of application than on correct direction of the practice.

Drawing

The traditional term 'watercolour drawing' is a more accurate description than 'watercolour painting'. Basically the forms used in painting are created spontaneously with the brush and the brush gives identity and expression to the work.. I suggest, therefore, that you draw, constantly, all sorts of things. Practice drawing in a sketchbook, so that you have a record of your progress. Draw directly with a variety of media, aiming to make your statements as simple and plain as possible. Also practice using a brush as a drawing instrument. Charge the brush with a basic colour, sepia or a grey, and make the statement as strong and direct as you can without crudity.

Preparatory drawings and notes are also extremely helpful in sorting out the essential elements of design and the realization of the idea.

Colour/tone

The insipidity of many watercolours is caused by a lack of balance between the pigment and the water content. Stretch a piece of paper and practice making the strongest colour statement you can with a progressively increasing volume of water, so that you move from a powerful, opaque area to a pale, transparent one. Make each stage a separate progessive development from the one before. Do this several times until you can safely predict the relative dried-out tone. Then reverse the process, from pale to strong. Experiment by changing the areas in proportion to the tone expressed.

From this move on to direct studies made with the brush from nature. Make each brushmark separate and conscious and build up form or distance by a progressive development of colour values, creating space or volume by the relationship of the values to one another.

Study

Study good examples. Examine Cotman drawings to understand how a firm simplification of colour values gives strength without complexity. Wash drawings by Rembrandt and Claude Lorraine will teach you much about eloquent expression in simple brush statements. Try to concentrate on the principles expressed and not merely on the technical mannerisms.

Painting outdoors

Because of its sensitivity in recording changes of light and atmosphere, watercolour is particularly suited to outdoor painting, whether of quick studies or more complete works; so it may be useful to discuss some of the problems involved.

It seems to me that most students' problems are less technical than perceptual, and for this reason my advice is concerned more with the basic attitude to landscape painting than with technique.

Choice of subject

'We see nothing truly till we understand it' (John Constable). Select a landscape subject which you find interesting and preferably one which is well known to you. Get the feel of it, walk about in it if you can.

Consciously identify the characteristics. Enumerate them to yourself: levels — contours — distances involved — types of growth, structure, and so on — buildings, if any, and their scale.

Study the light: the quality of the light — how it reveals the subject — the direction and altitude of the sun — time of day — weather conditions — direction of wind — movement of clouds. All these factors have probably had an influence, conscious or otherwise, on your choice of subject.

What is the dominant aspect? What do you wish to express? An idea may strike you immediately, or it may develop slowly, growing and changing. What are the essentials for realizing the idea? Does your subject depend upon a particular time of day, or quality of light? (It probably does.) If so, which and to what extent? What are the essential forms and groupings of masses? What is irrelevant to your idea?

Consider colour. Is there a scheme of colour? Or a dominant key of colour? For example, the subject may be essentially warm, or cold, or a mixture of both. What are the dominant colours and the subordinate colours, and what is the proportion of one to the other?

Some basic advice

1. Prepare your paper in advance.
2. Bearing in mind the overall scale and size of working, consider an appropriate shape, don't just use any old proportion.
3. Select a range of appropriate colours.
4. Concentrate on the overall simple idea. See the minor forms in relation to the major.
5. Use what you find in the subject, don't invent incident.
6. Stop as soon as you have said what you want to say in your painting.

Equipment

Keep your equipment simple and light to carry. What you use eventually will depend largely on personal choice and circumstance. My suggestions for outdoor painting equipment are as follows.

1. An easel which will hold a board almost horizontally.
2. Paper stretched in advance on smallish boards (offcuts may be purchased from a wood store or do-it-yourself shop).
3. A carefully selected range of colours, preferably in a box with large mixing palettes. If this is not possible white enamelled or china plates make good substitutes.
4. A few good-quality brushes.
5. A small sponge.
6. An adequate quantity of clean water, and water pot.
7. A generous supply of clean rag.
8. Drawing materials.
9. A notebook.

ACKNOWLEDGEMENTS

Text, drawings and paintings by Leslie Worth.

Text, illustrations, arrangement and typography copyright © Search Press Limited 1980.

First published in Great Britain 1980
Search Press Ltd, Wellwood, North Farm Road,
Tunbridge Wells, Kent.

12th impression 1992.

Distributors to the art trade:

UK

Winsor & Newton,
Whitefriars Avenue, Wealdstone,
Harrow, Middlesex HA3 5RH

USA

ColArt Americas Inc.,
11 Constitution Avenue, P.O. Box 1396, Piscataway, NJ 08855–1396

Arthur Schwartz & Co.,
234 Meads Mountain Road, Woodstock, NY 12498

Canada

Anthes Universal Limited,
341 Heart Lake Road South, Brampton, Ontario L6W 3K8

Australia

Max A. Harrell,
P.O. Box 92, Burnley, Victoria 3121

Jasco Pty Limited,
937–941 Victoria Road, West Ryde, N.S.W. 2114

New Zealand

Caldwell Wholesale Limited,
Wellington and Auckland

South Africa

Ashley & Radmore (Pty) Limited,
P.O. Box 2794, Johannesburg 2000

Trade Winds Press (Pty) Limited,
P.O. Box 20194, Durban North 4016

ISBN 0 85532 401 5

Made and printed in Spain by Artes Graphicas Elkar, S. Coop.
Autonomía, 71 - 48012-Bilbao - Spain.